Arabesque

A

Collection of original drawings to Color

Copyright 2016

by Sarah Reyburn

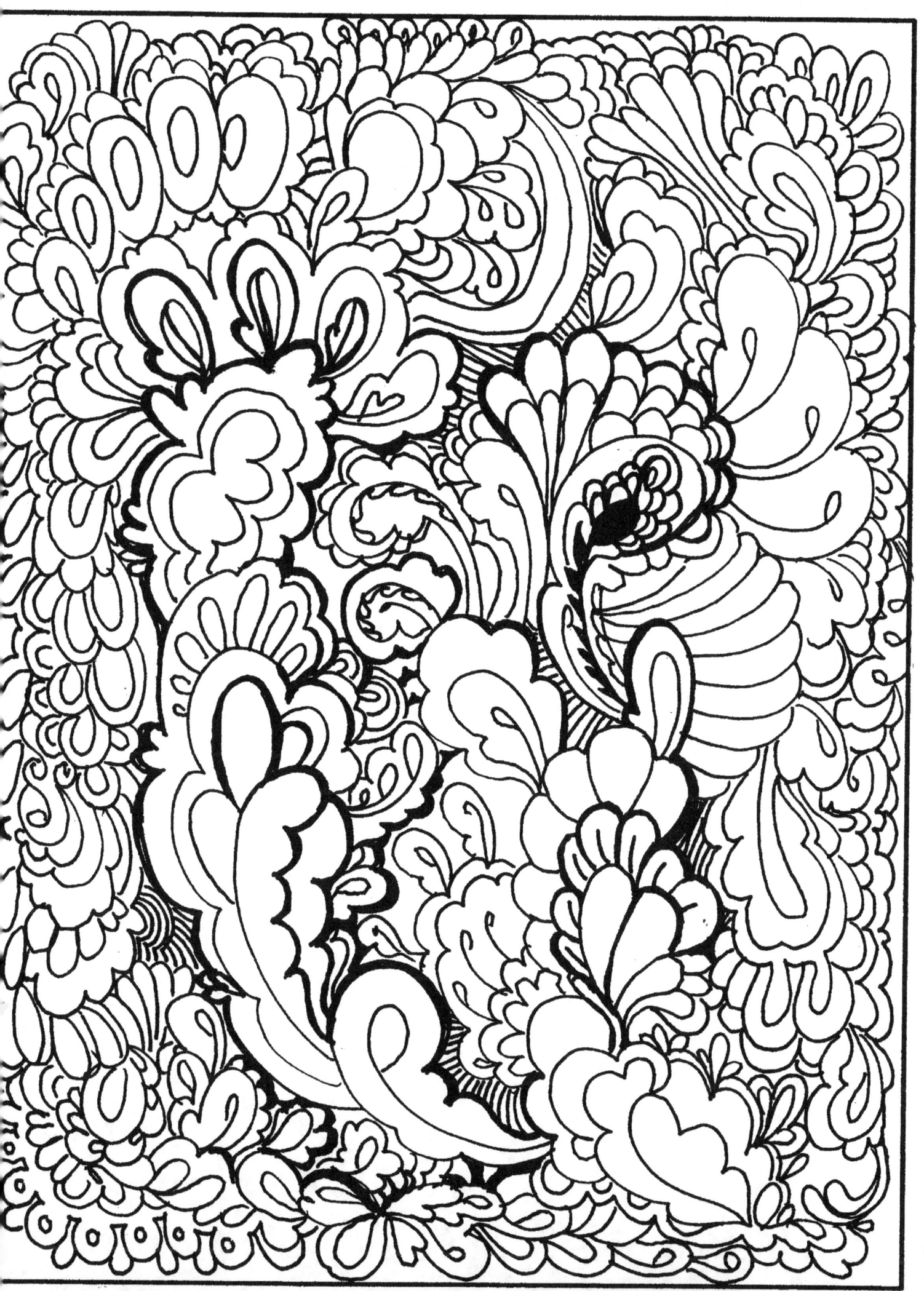

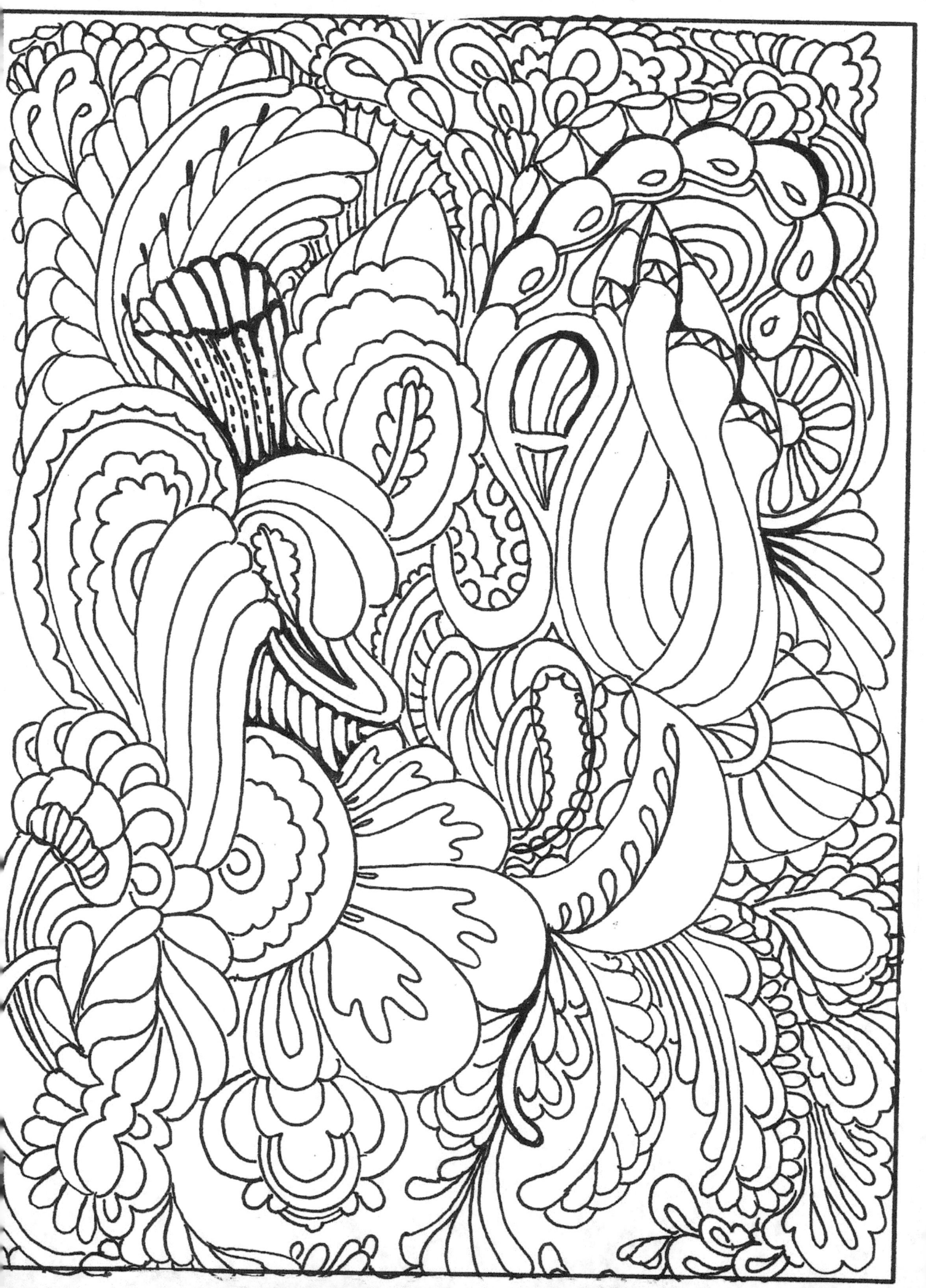

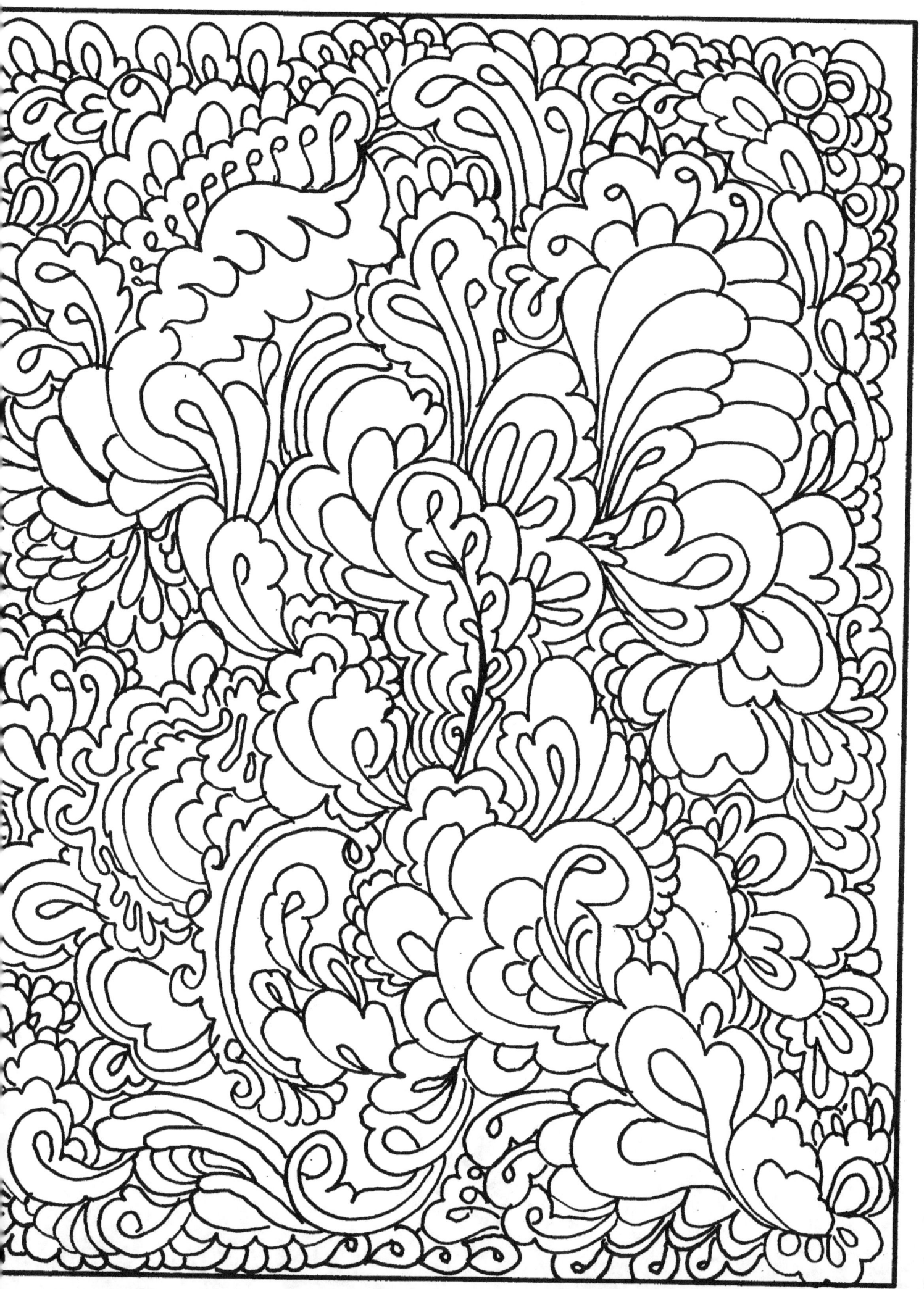

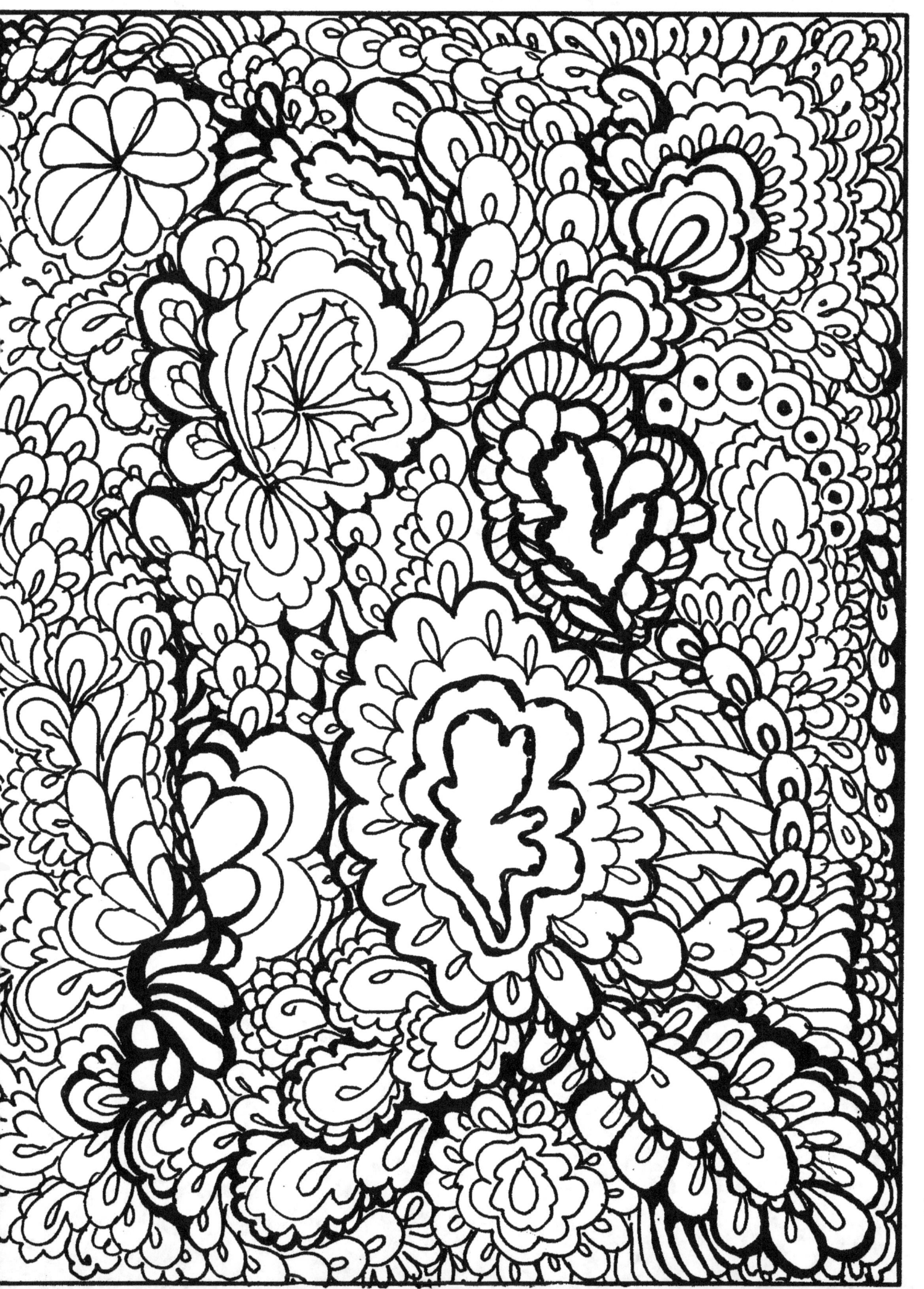

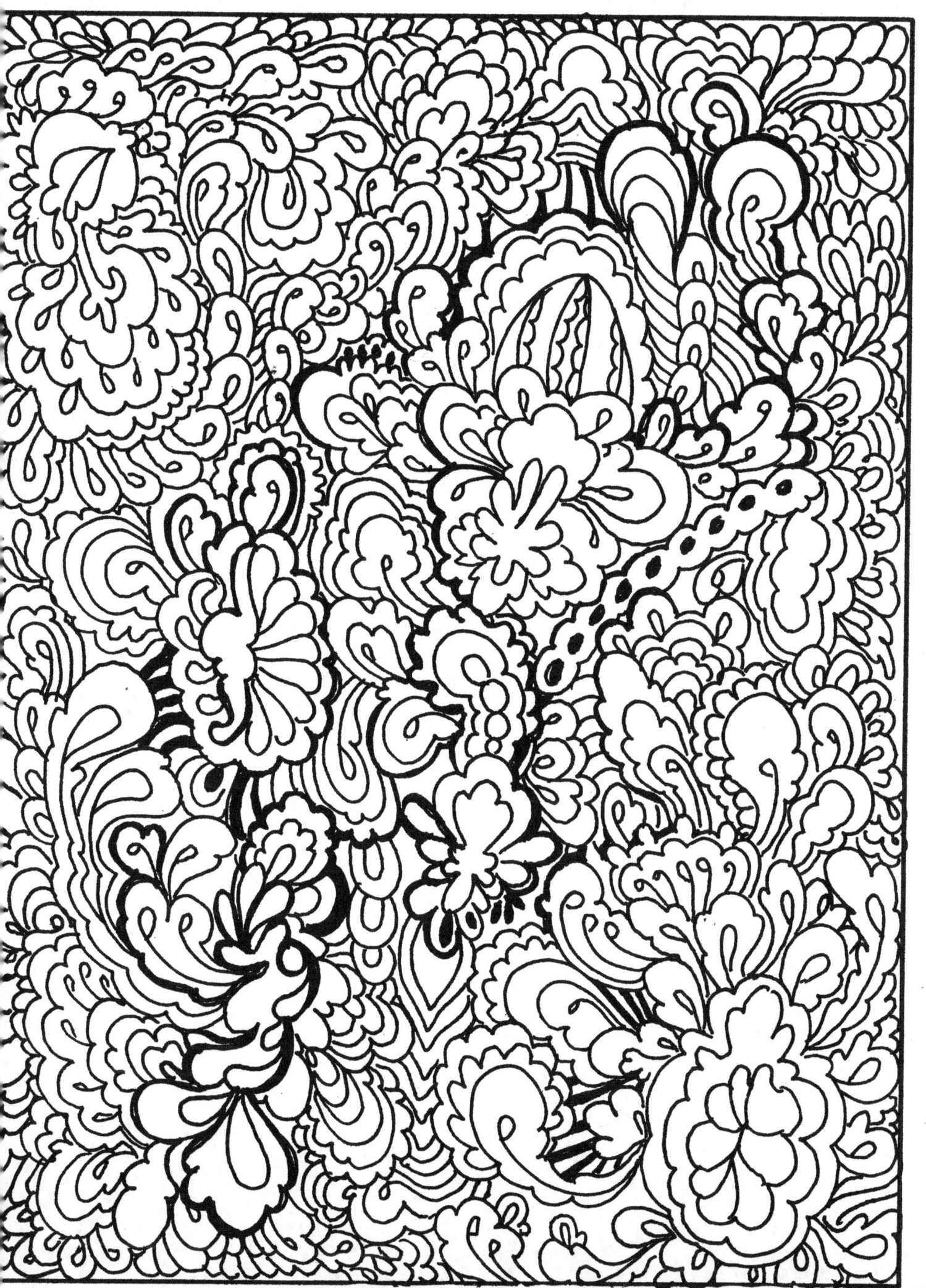

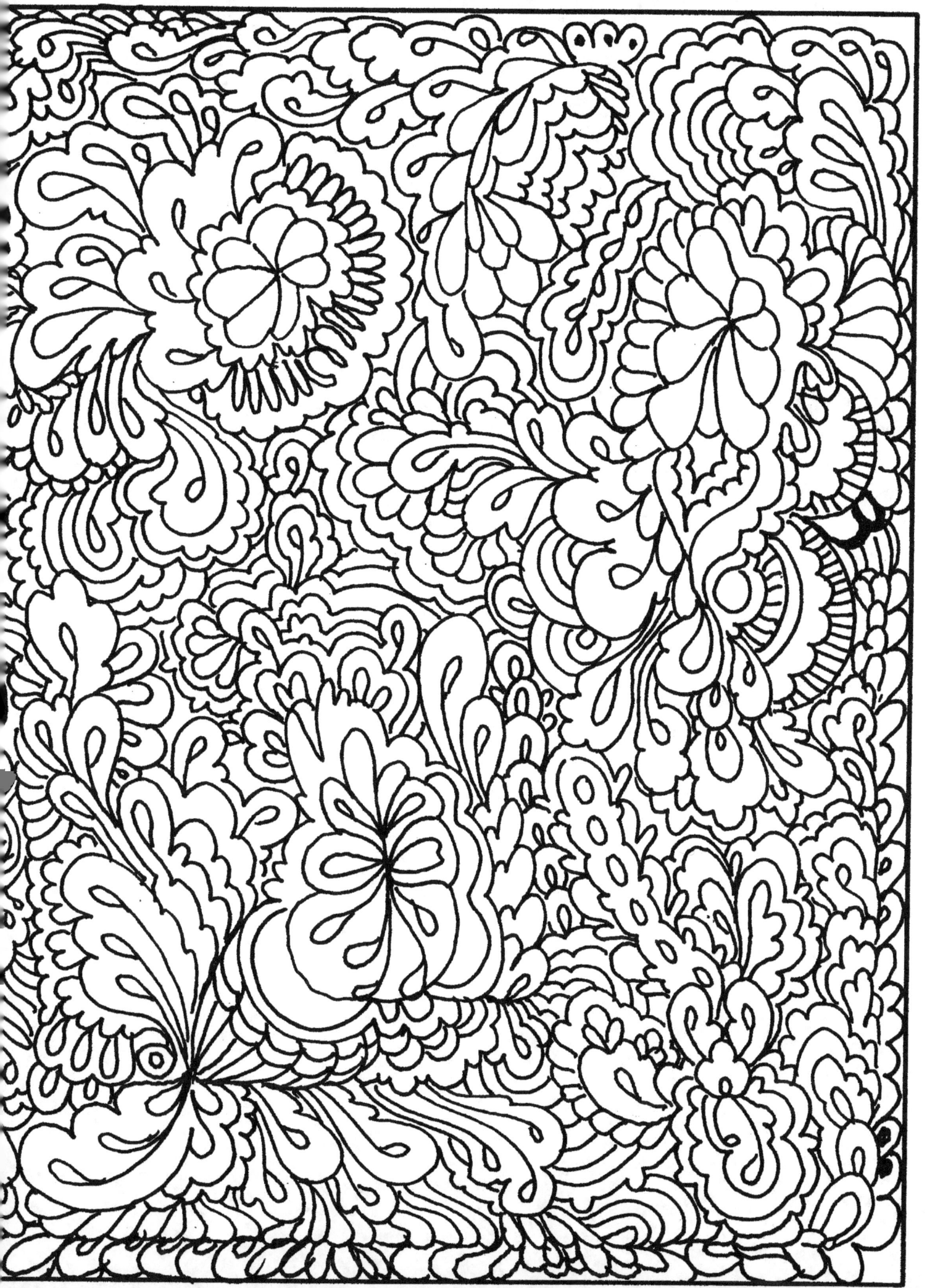

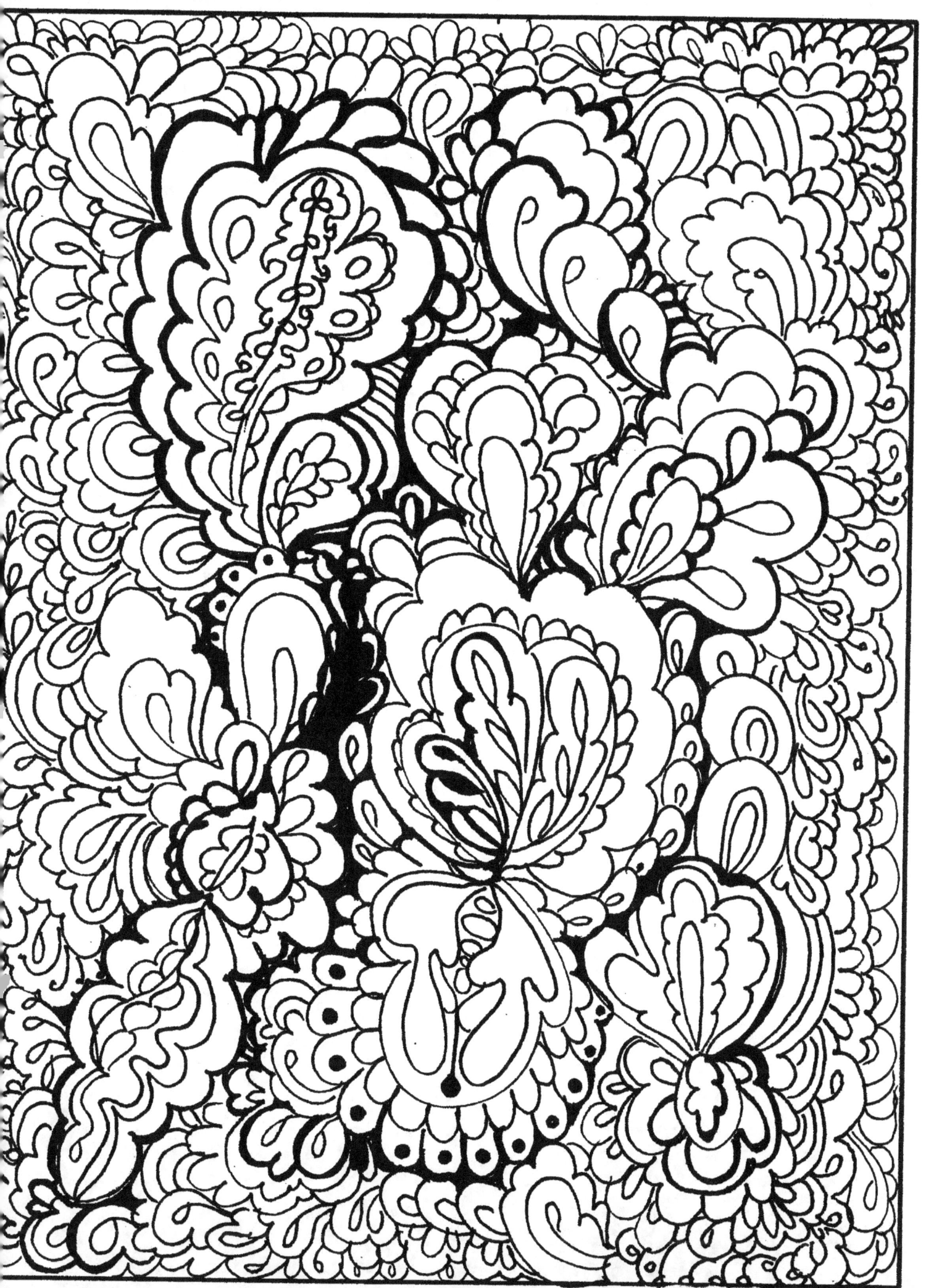

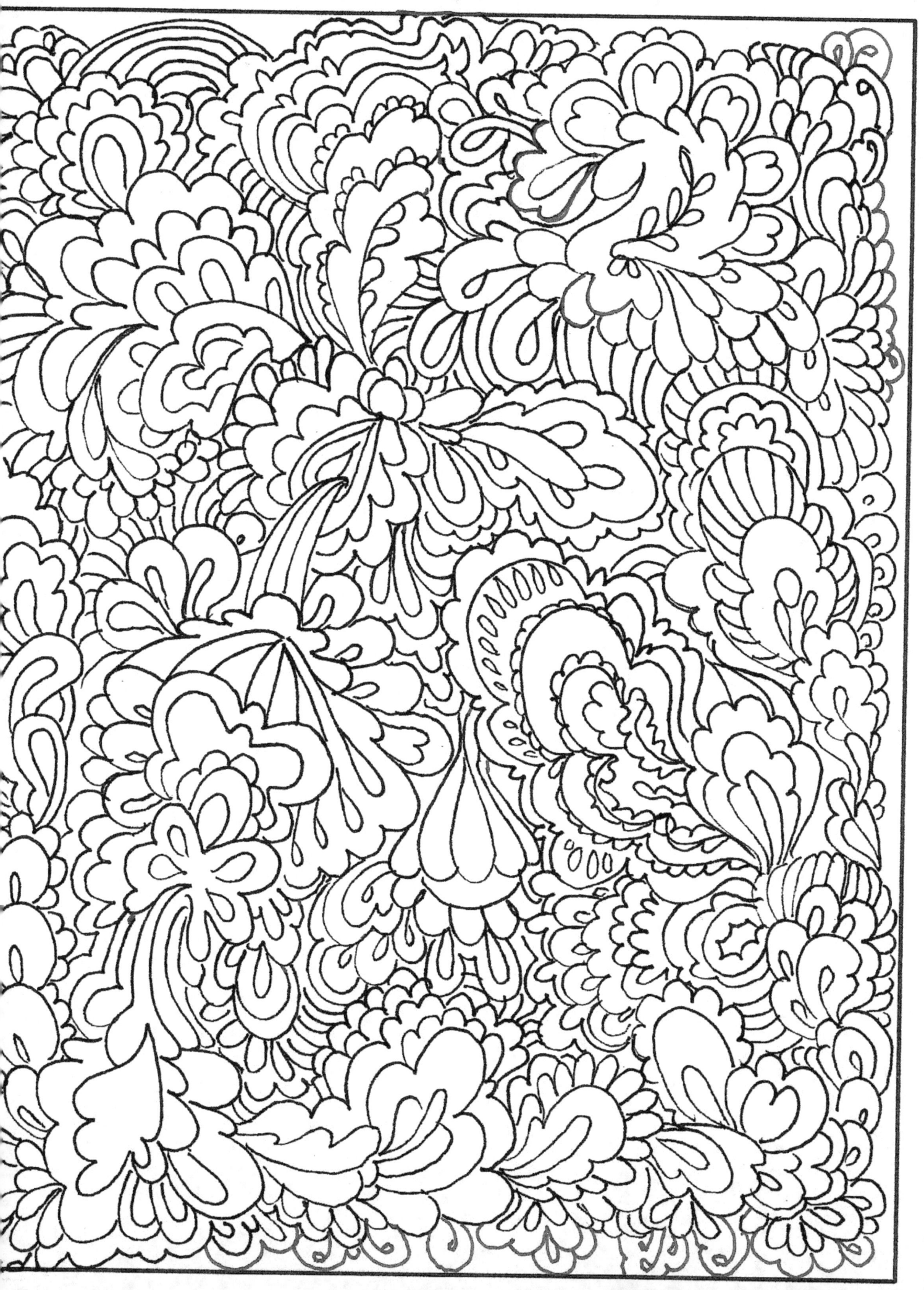

www.ingramcontent.com/pod-product-compliance
Lightning Source LLC
Chambersburg PA
CBHW081147170526
45158CB00009BA/2757